-Brain Vomit-
A collection of art
by Himitsu

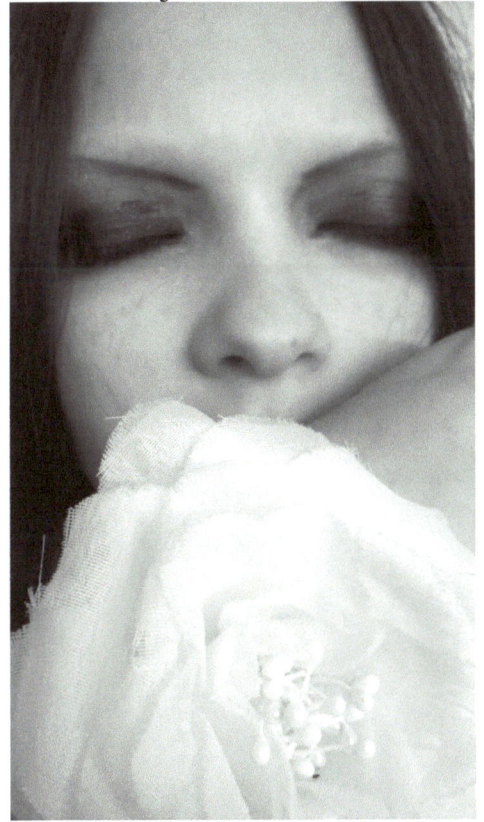

Himitsu paints in an avant-garde and expressionist style with mixed media. Still life & nature paintings sit beside rough and gritty punk and gothic art in this collection of work from 2010-2016.

For info, shop, & email newsletter, visit
www.enigmatic.net76.net

All designs in this book are featured in the web shop on various accessories and goods, and as posters.

Copyright © 2016 by Himitsu

All rights reserved. This book or any portion thereof may not be reproduced or used in any manner whatsoever without the express written permission of the publisher except for the use of brief quotations in a book review or scholarly journal.

First Printing: 2016

Second Edition

ISBN 978-1-329-84633-3

*Dedicated to the universe, and everyone I've met in my life.
It is your beauty and atrocity that inspires me.*

When I was younger, I used to spend a lot of time drawing. It kept my mind on something and away from the melodrama of school or family. I did some painting, and studied realism and manga styles as well as developing my own. I used to doodle little comics and my preference for drawing monsters, cats, and creepy things evolved into people and landscapes.

When I started painting with mixed media, it was a major outlet for emotion. The first time I did it, I was inspired by punk and gothic clothing designs, especially the ones from England and Japan that had strange artwork on them. I sat down, grabbed a box of random art supplies, and thought, "What if I just use everything in front of me to make whatever pops into my head without stopping or analyzing the thoughts?" So I made a bizarre, angst-filled stream of consciousness design and found it very therapuetic. The result was 'Condemnation', still one of my favorites.

This collection of artwork shows both a dark and light side of my mind. There are works that came from misery and reflecting negatively upon society as well as art that was made in appreciation of nature and beautiful forms, or inspired by love. Although a few lack complexity and are very rudimentary, I still included them because they have a story.

I hope they can bring calm and tranquility to the mind of the viewers, and invoke emotions and deep thoughts as well as just looking cool on a backpack.

-Himitsu

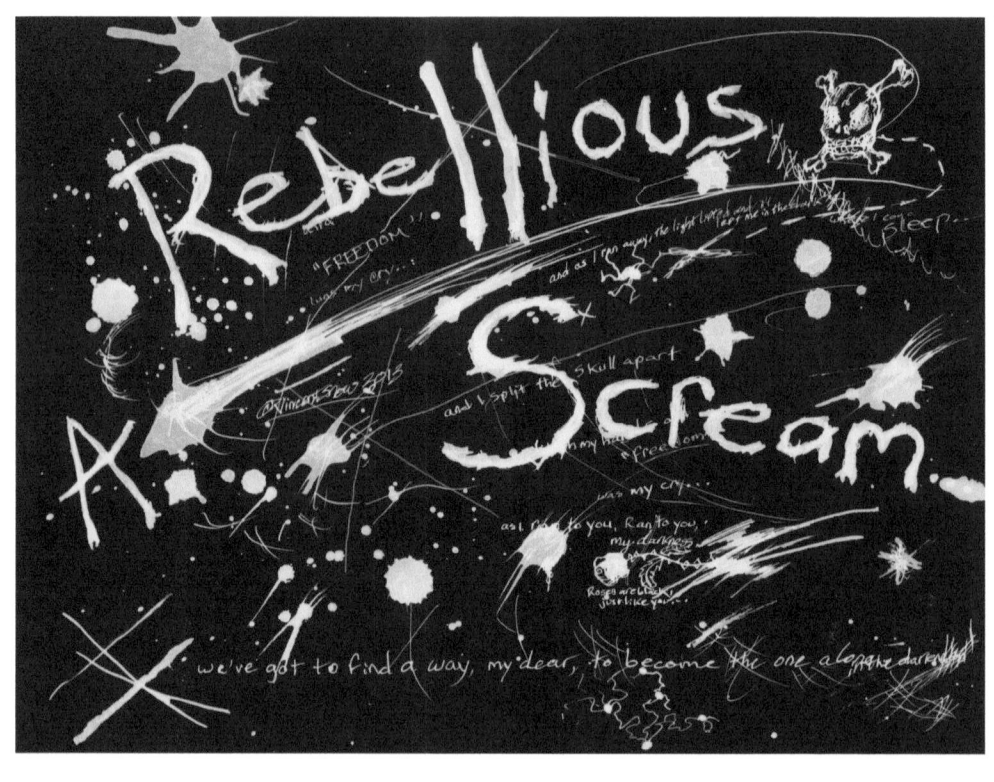

A Rebellious Scream (Black Version)
Ink & Digital editing
2013

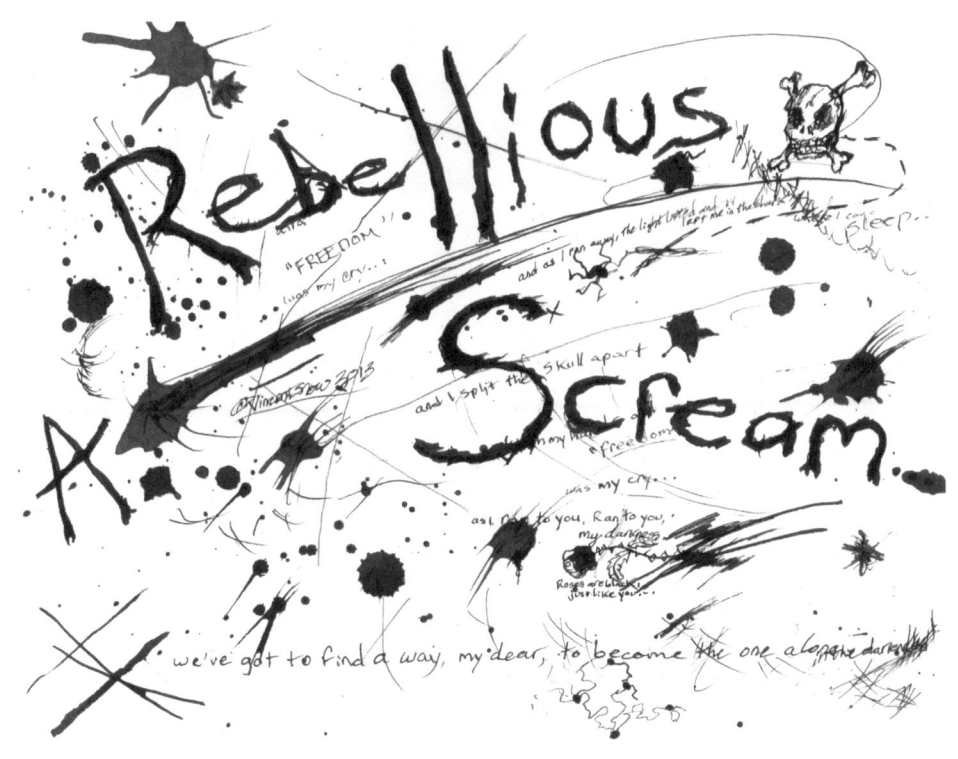

A Rebellious Scream -White Version-
2013
Ink

These were both originally made as logos. It was a name idea for a punk clothing line, which I later abandoned. Although, I still occasionally make handmade clothes and accessories for a hobby.

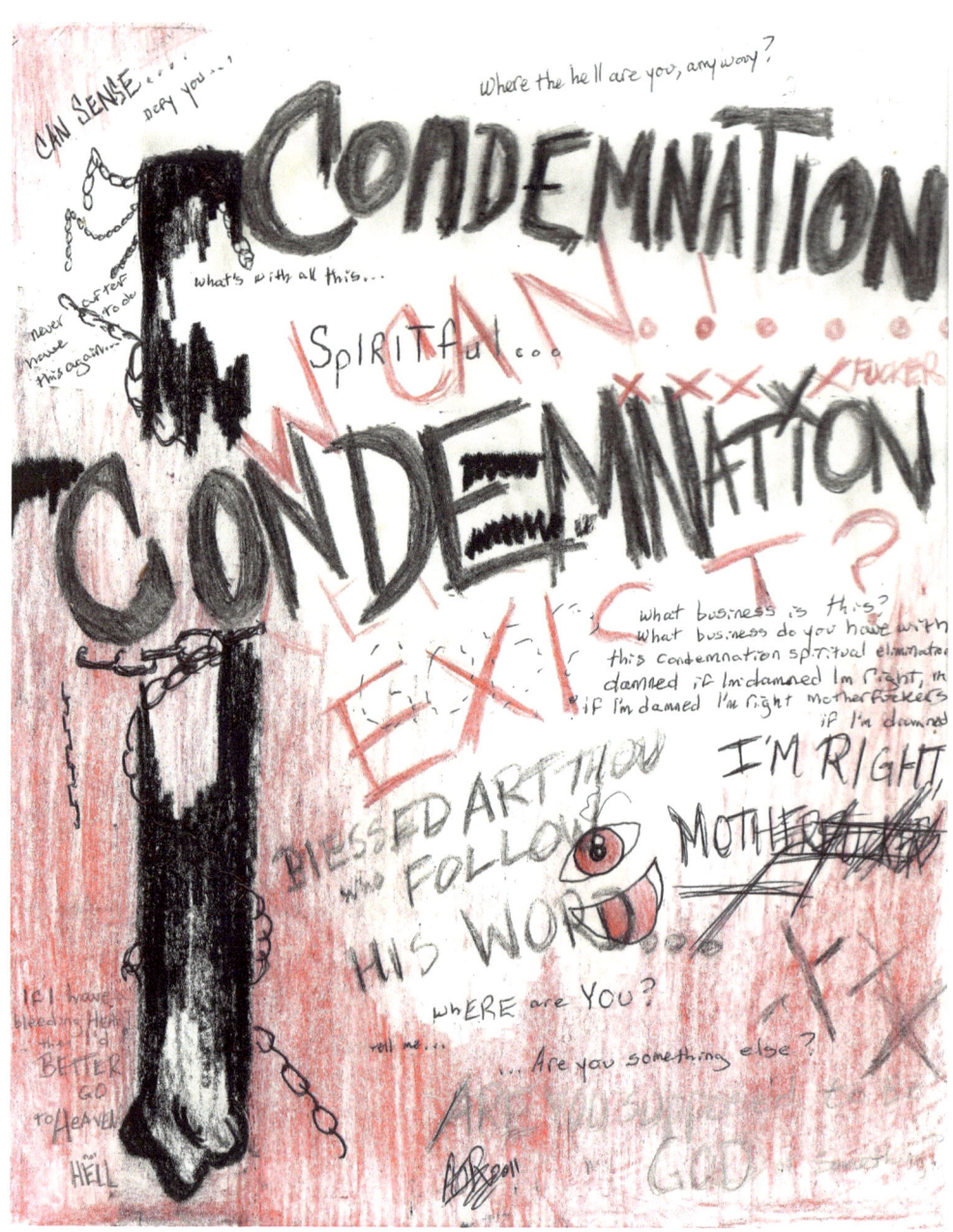

Condemnation (2011) – Crayon, china marker, colored pencil, ballpoint & felt ink pens.
A mess of thoughts spit out onto paper after a tough day…

MEMORIES

Memories are unforgettable terriby painful

I cannot forget

FORGET

[all these]

Memories...

HOW CAN I LIVE?

with all these

MEMORIES

I don't want

Memories crushing me bring me down anymore

I... MEMORIES these **MEMORIES!!!**

go away

Memories (2011)
Crayon, ink, china marker
Visual poem.

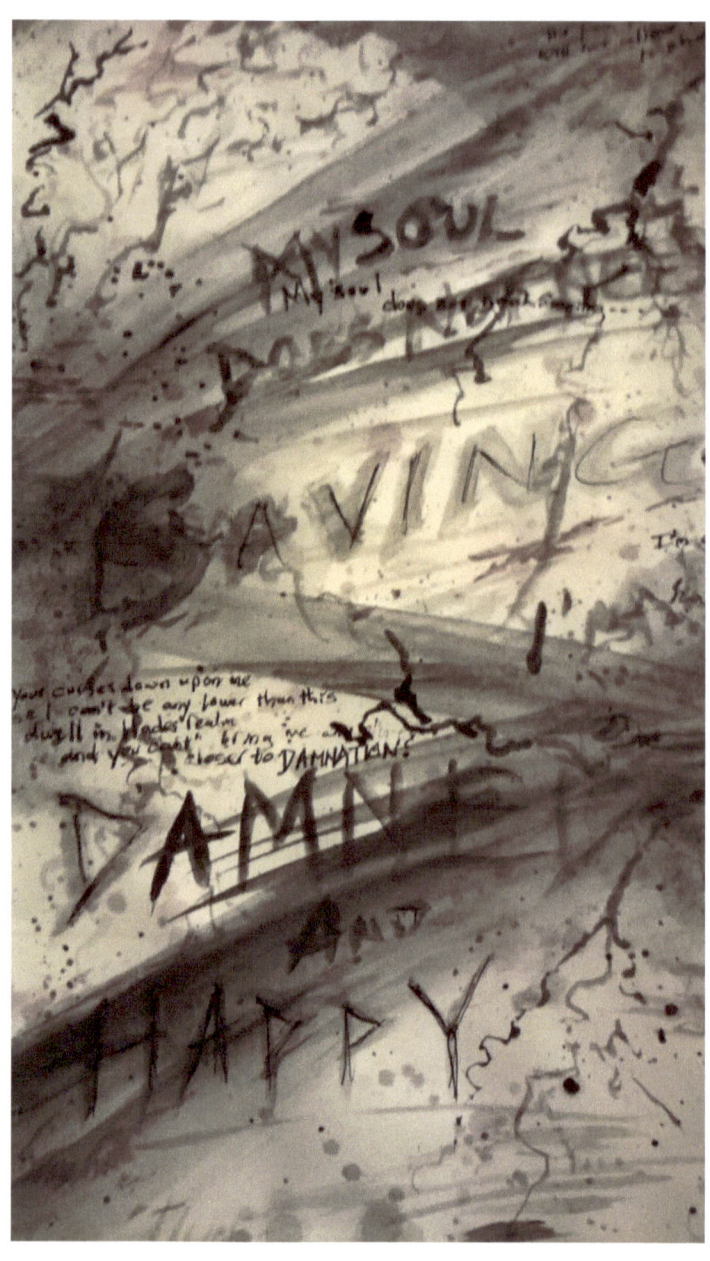

Damned and Happy (2015)
Ink and watercolor

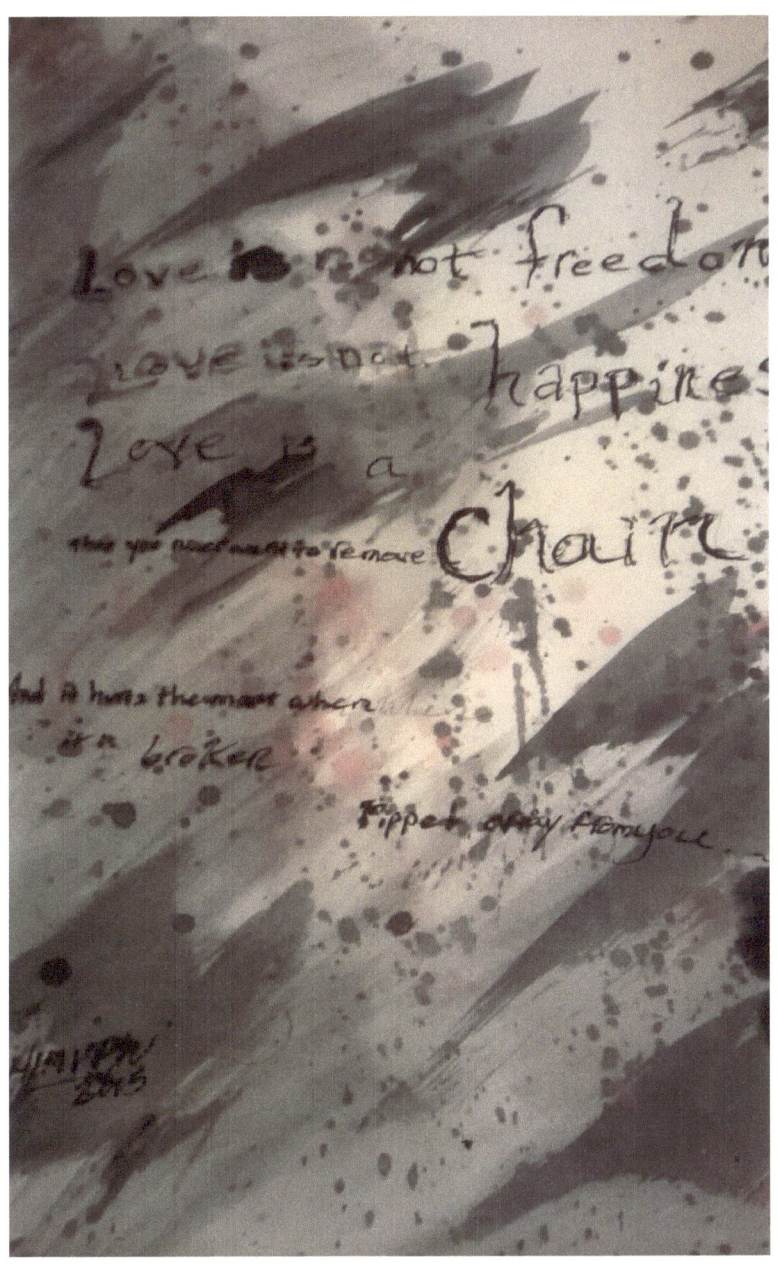

Love is a chain… (2015)
Ink and watercolor

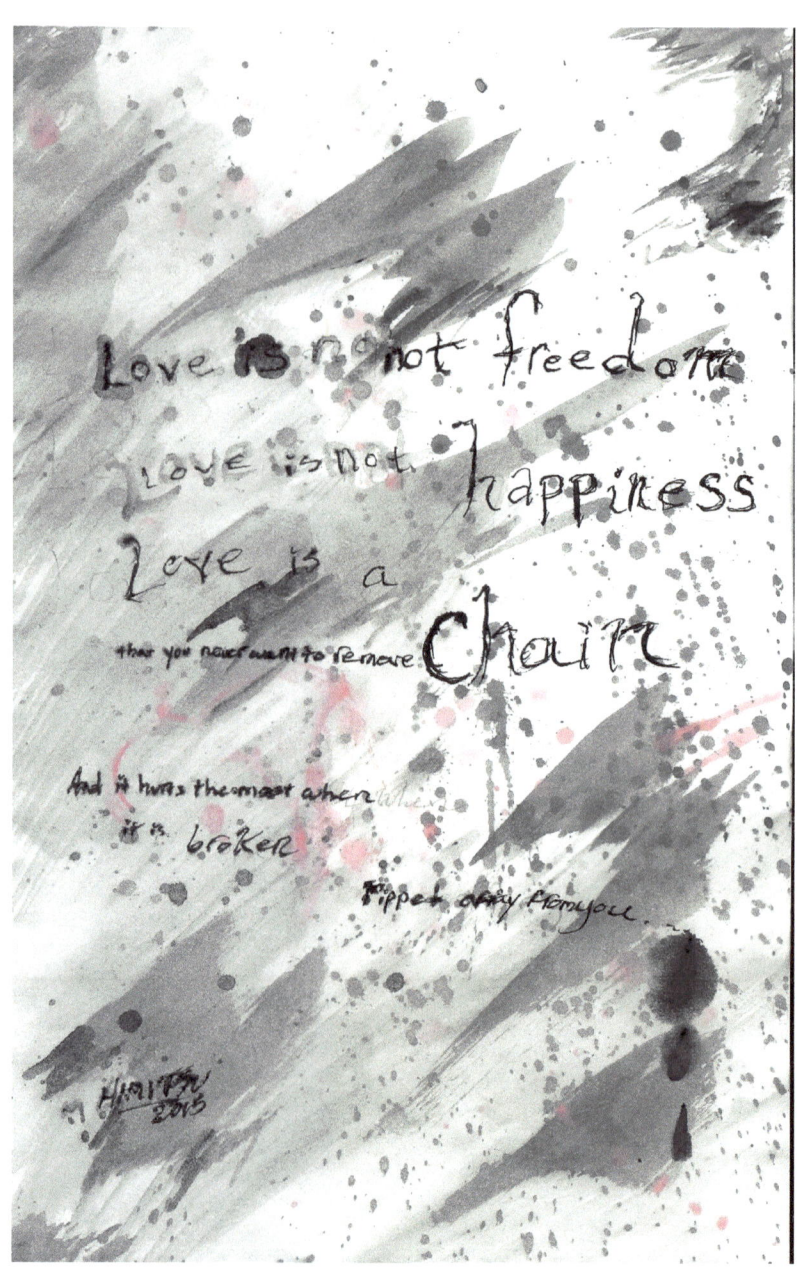

Love is a Chain… (2015)
Light colored version.

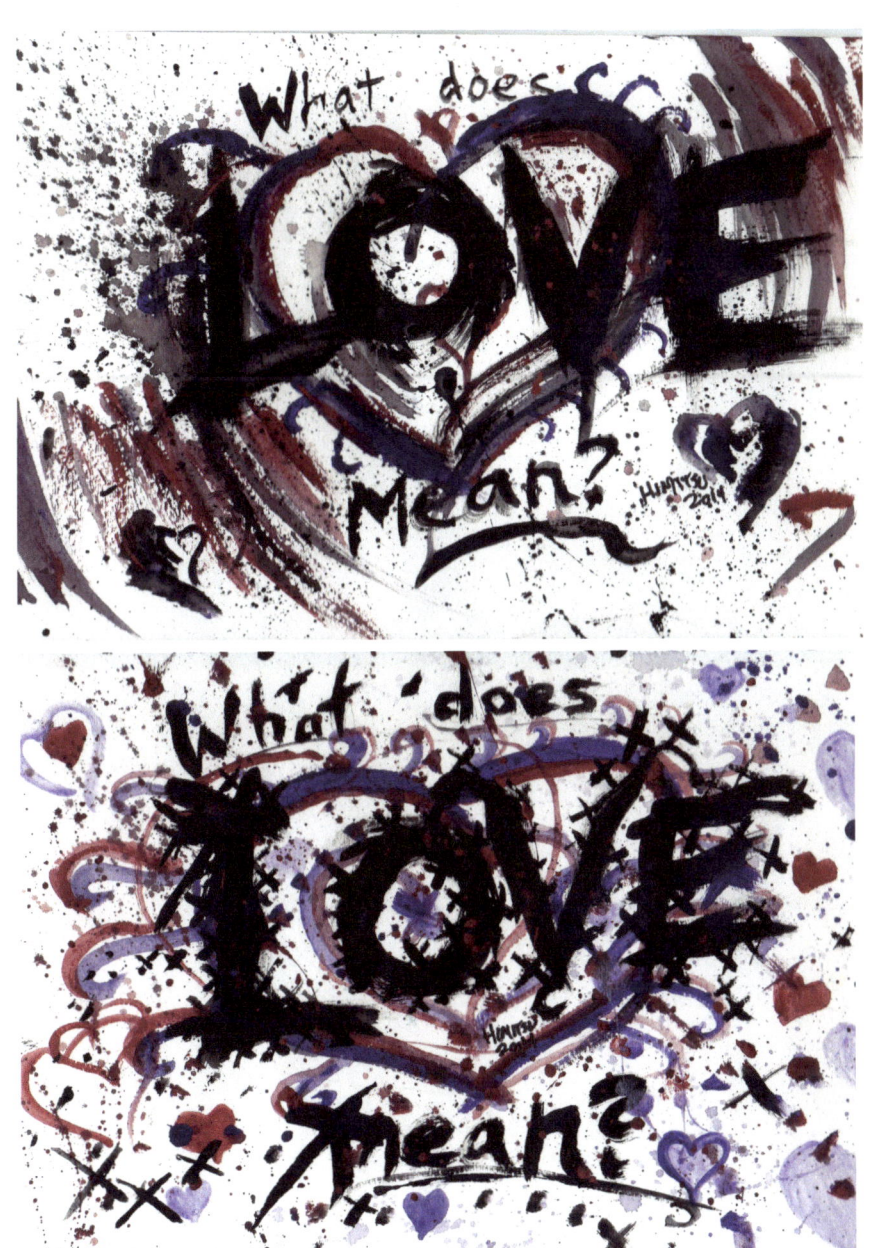

What Does Love Mean? (top) & What Does Love Mean?
-hateful version- (bottom) (2014)
Ink, watercolor, and acrylic paint.

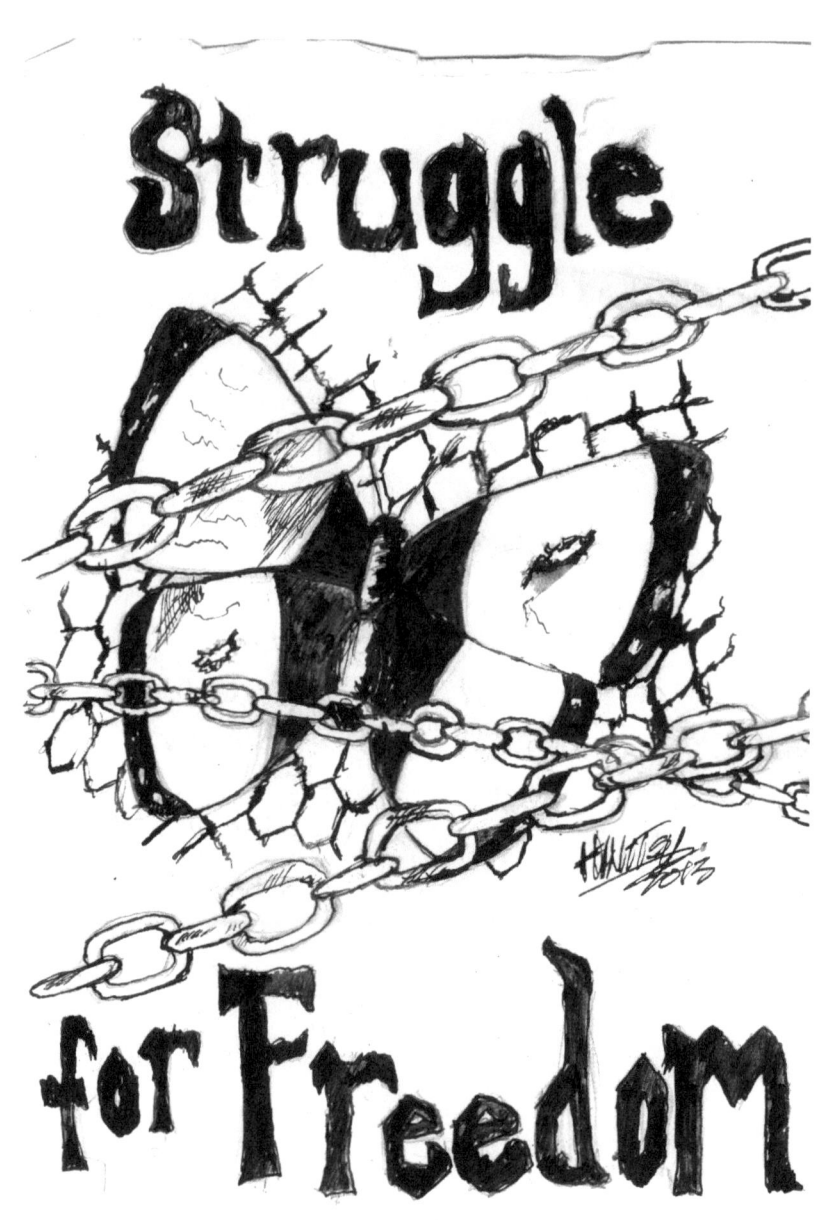

Struggle for Freedom (2013)
Ink and pencil sketch.
Originally intended to be a tattoo design.

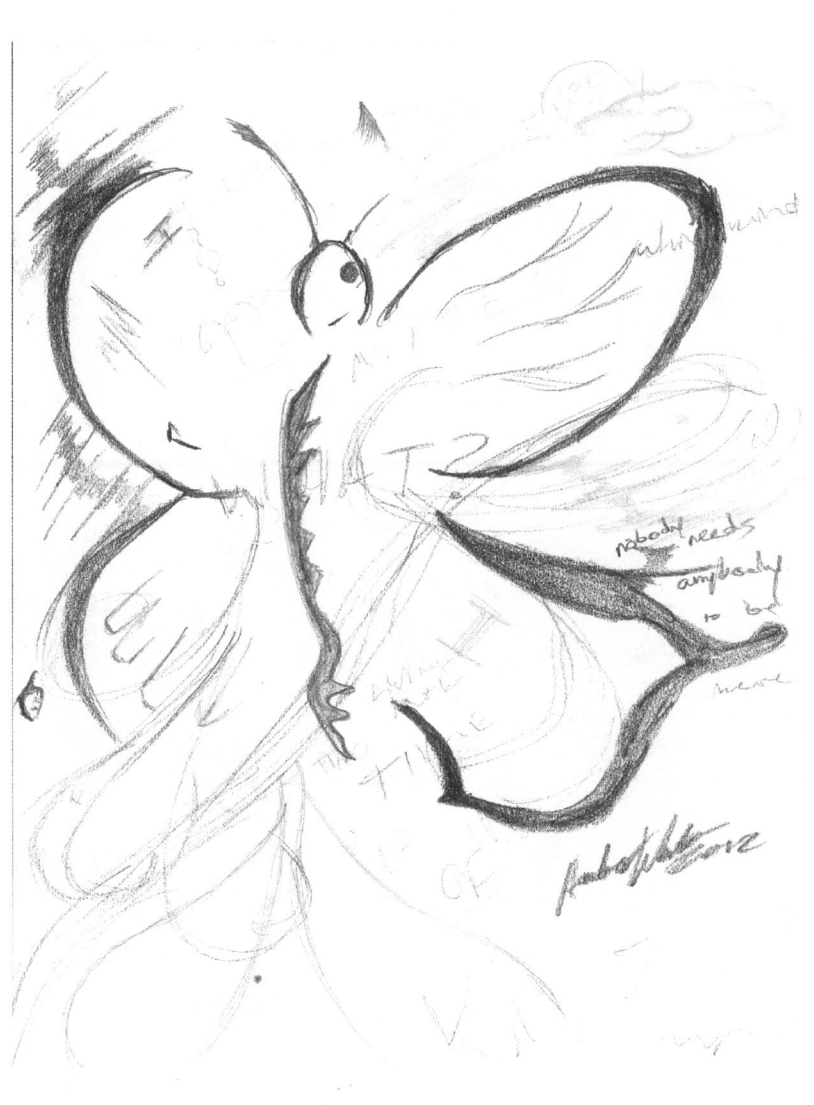

Broken Butterfly (2012)
Graphite

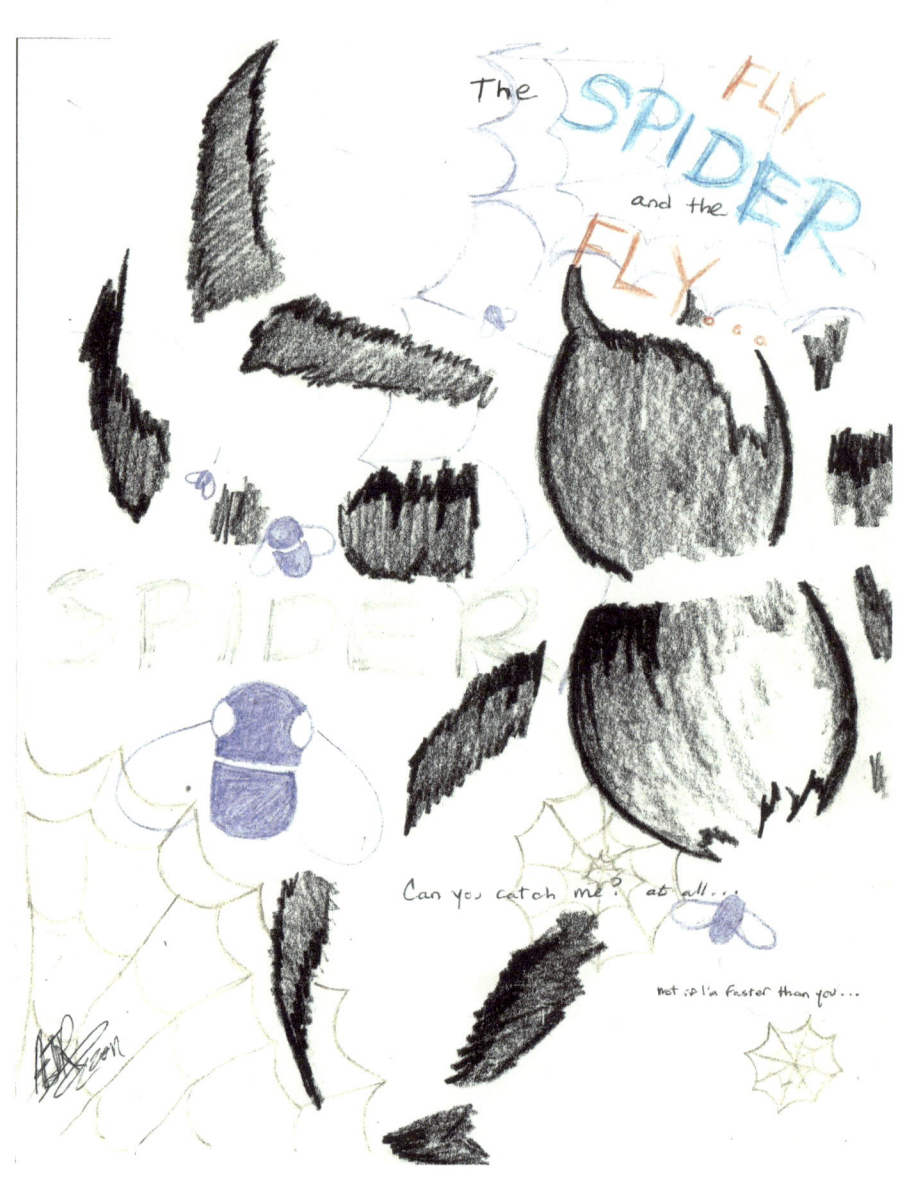

The Spider and the Fly (2011)
Colored pencil, crayon, ballpoint pen, and china marker.

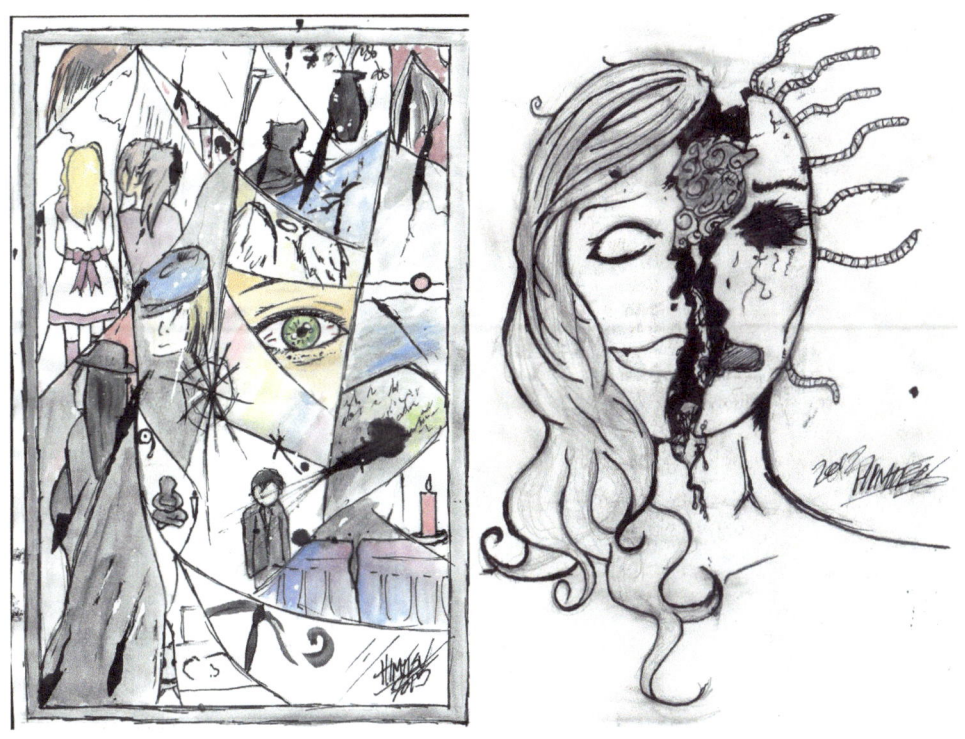

Left: If I only had a self…. (2015) Ink and watercolor.
Right: Self-portrait (2012) Pencil and ink.

Both of these are references to schizophrenia & MPD.

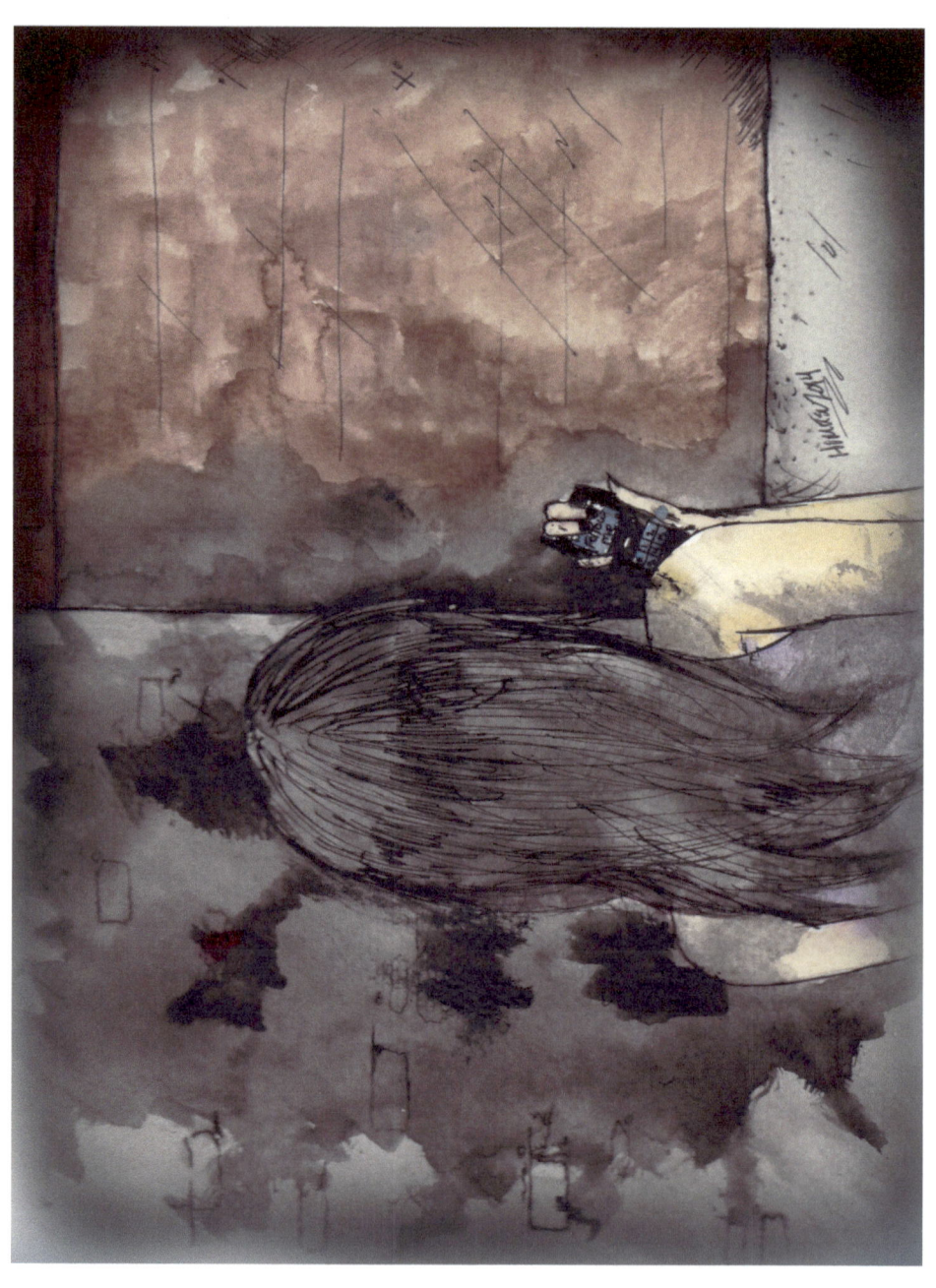

The Capture (2014)
Watercolor, Ink, and acrylic

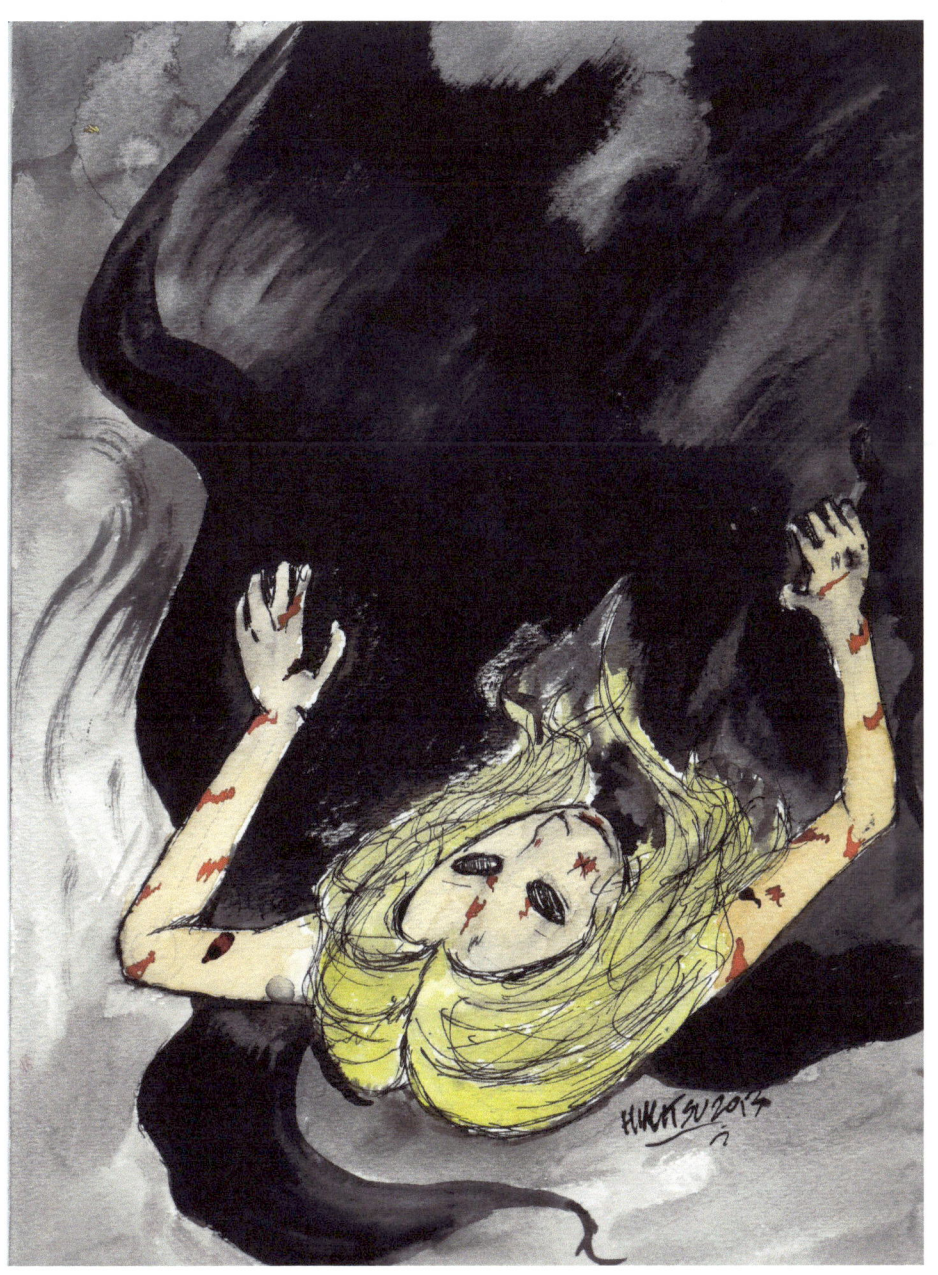

Buried underneath you (2013)
Ink, Watercolor, Acrylic

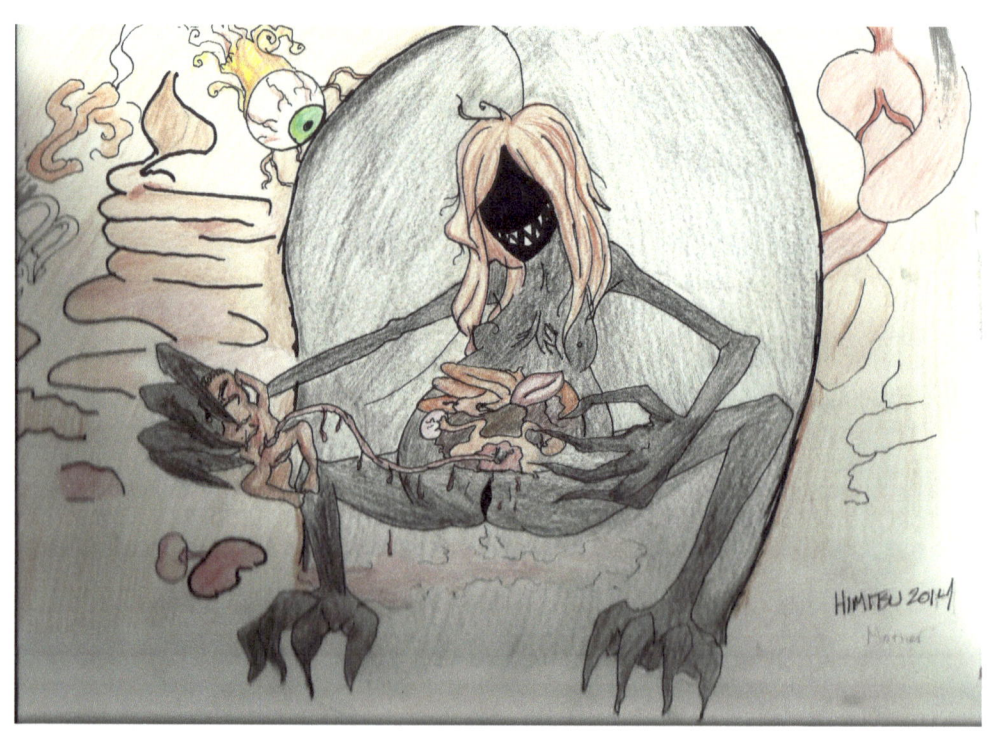

Mother-thing
(2014)
Colored pencil and ink

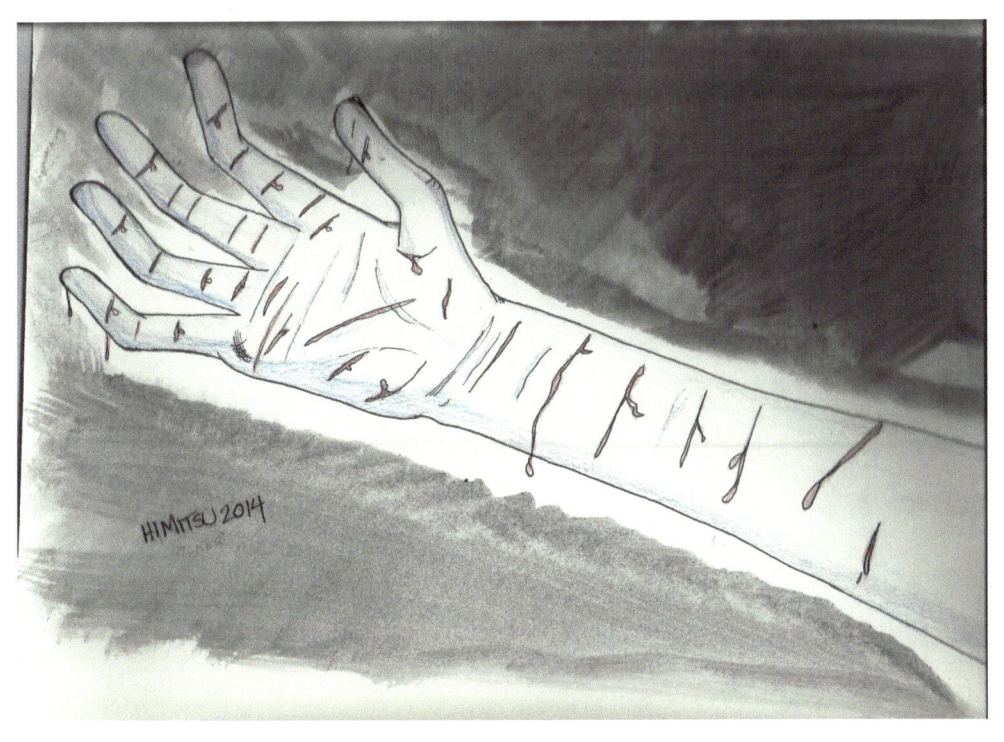

Glass cuts
(2014)
Acrylic paint, ink, and colored pencil

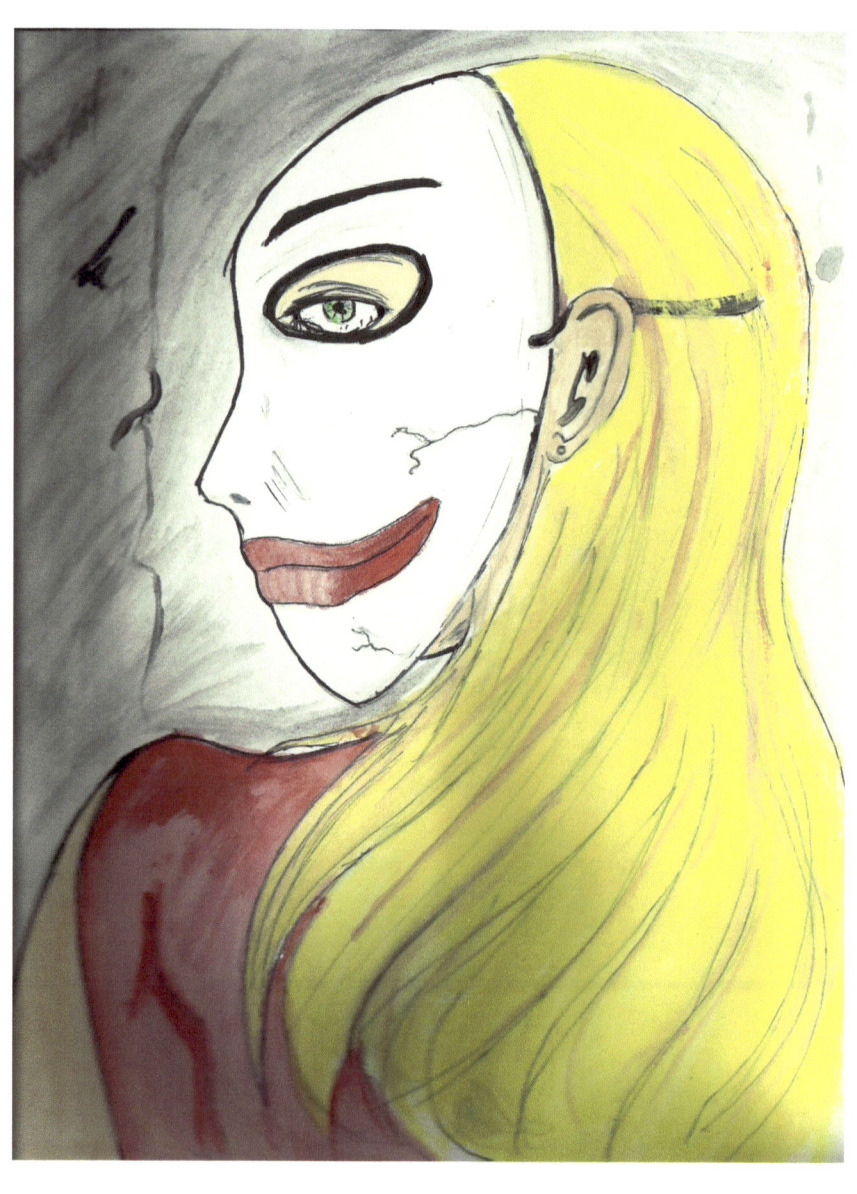

The lost girl (2014)
Acrylic paint and ink

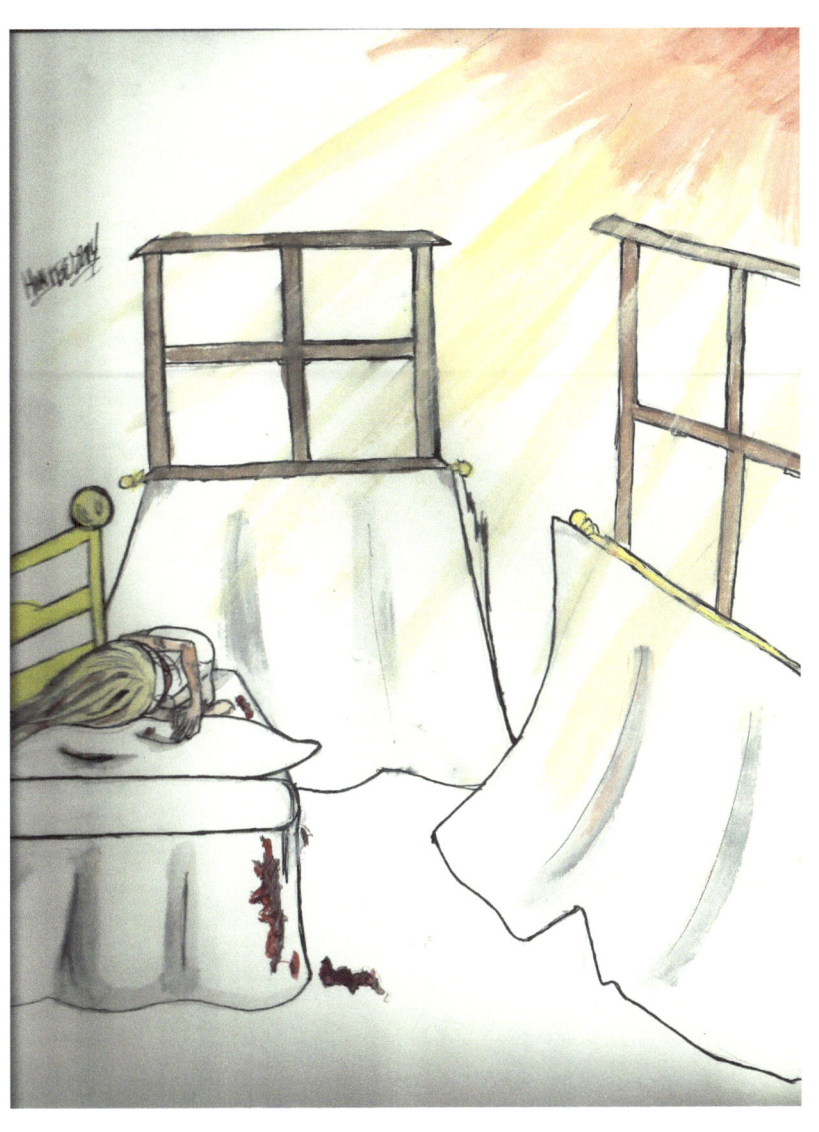

The Victim (2014)
Acrylic paint and ink

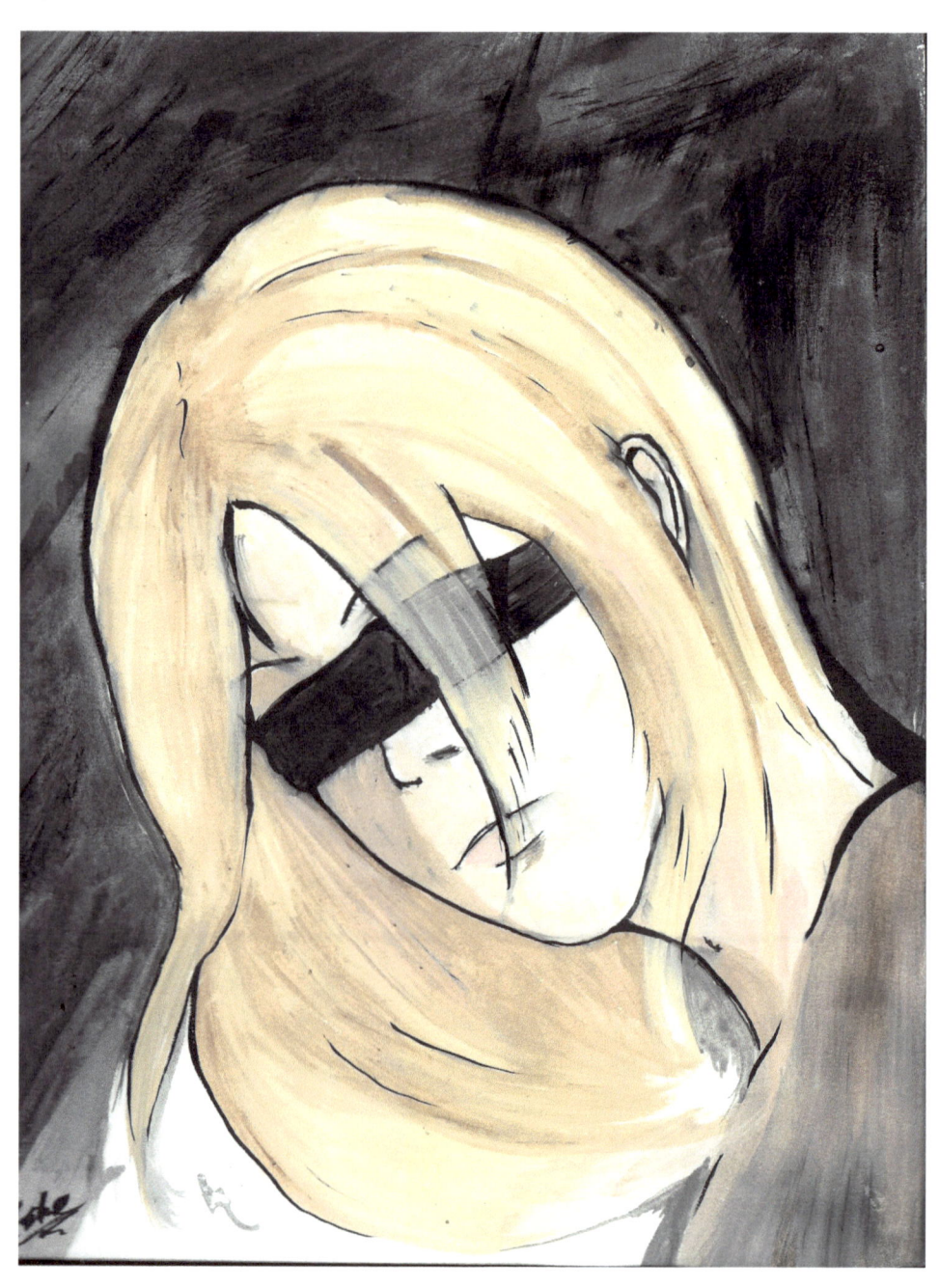

"Sleeping"
2014
Acrylic paint and Ink

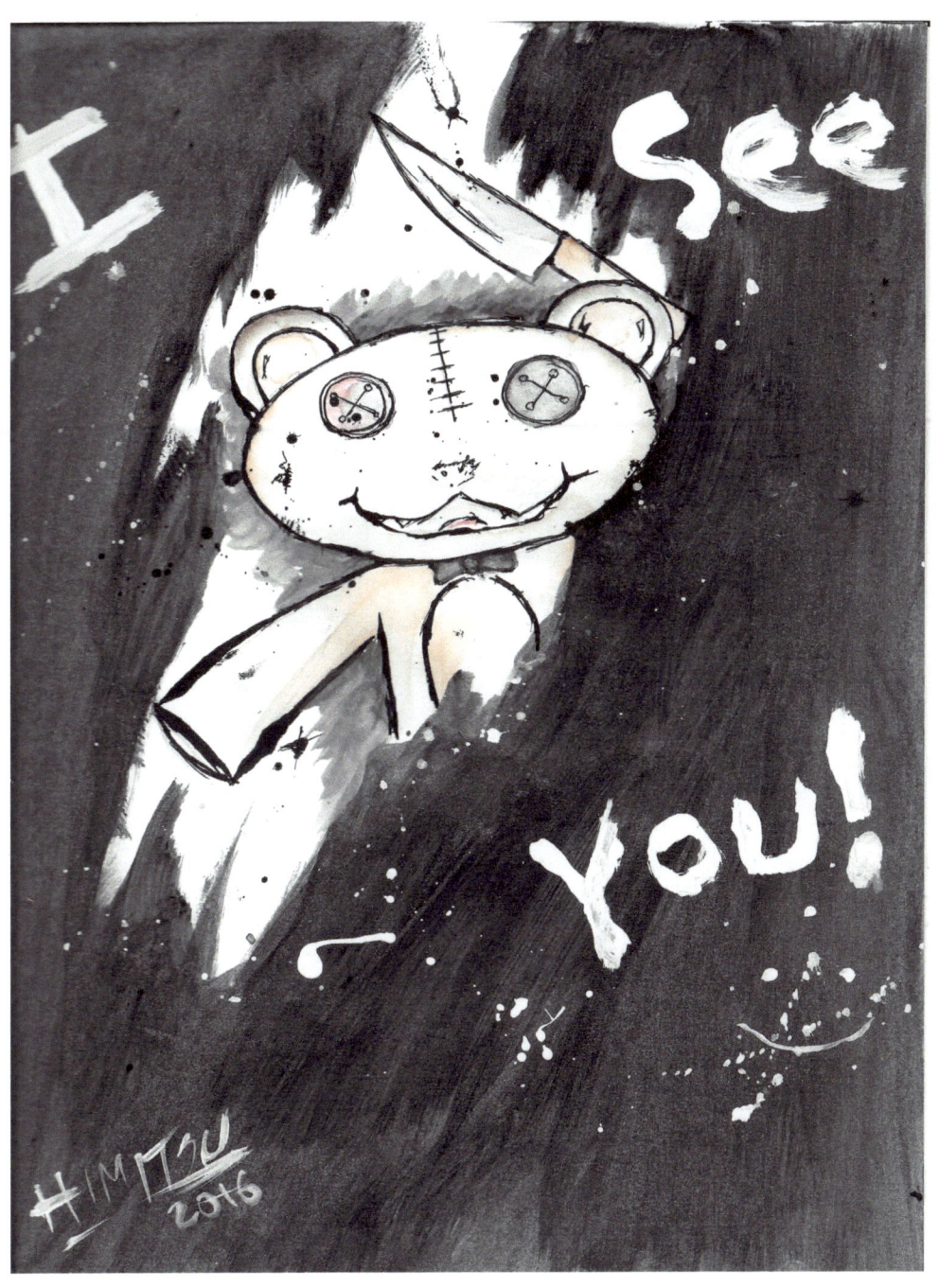

Spooky Bear (2016)
Acrylic, Ink, and Watercolor

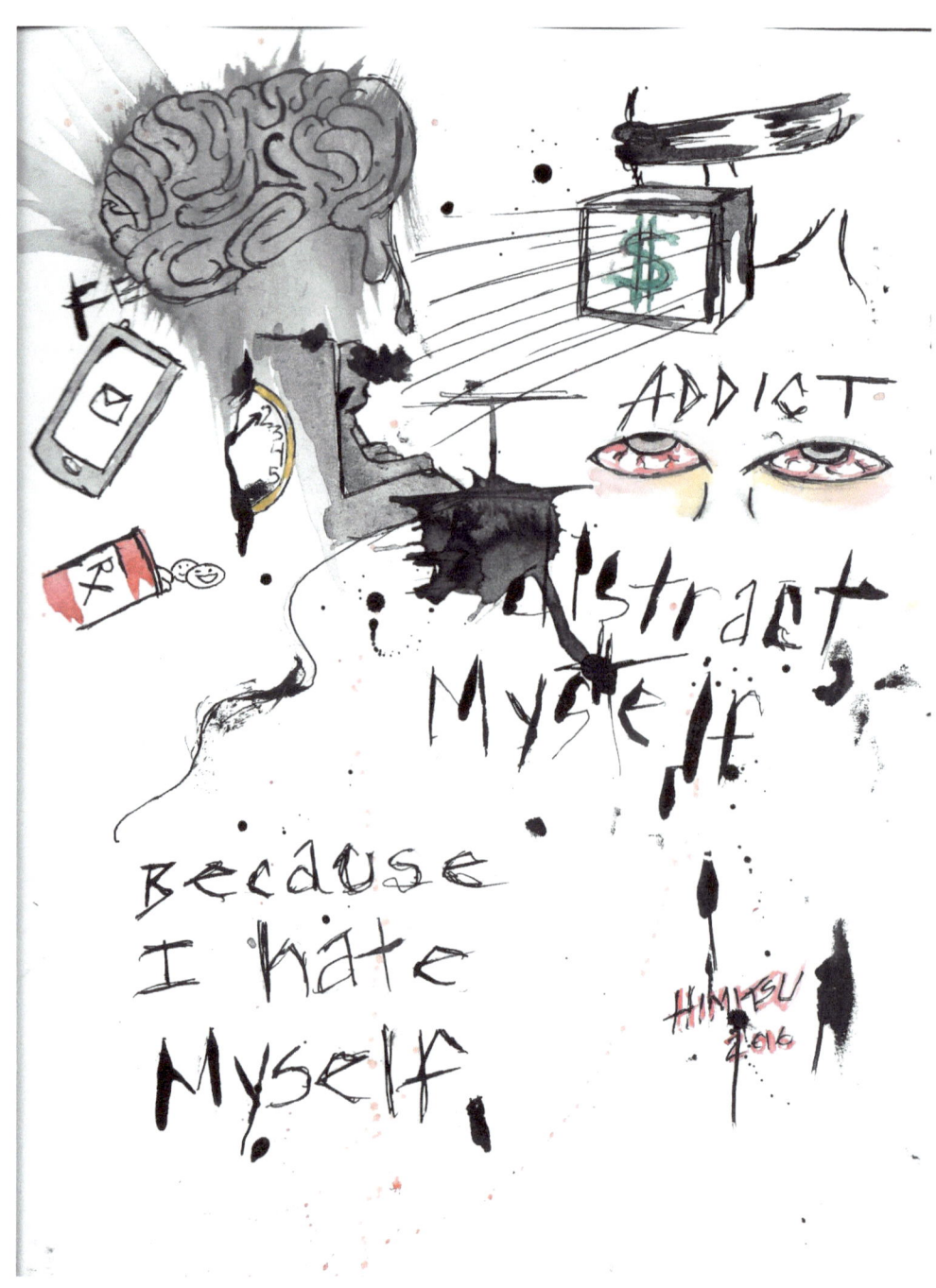

Distractions (2016)
Ink and Watercolor

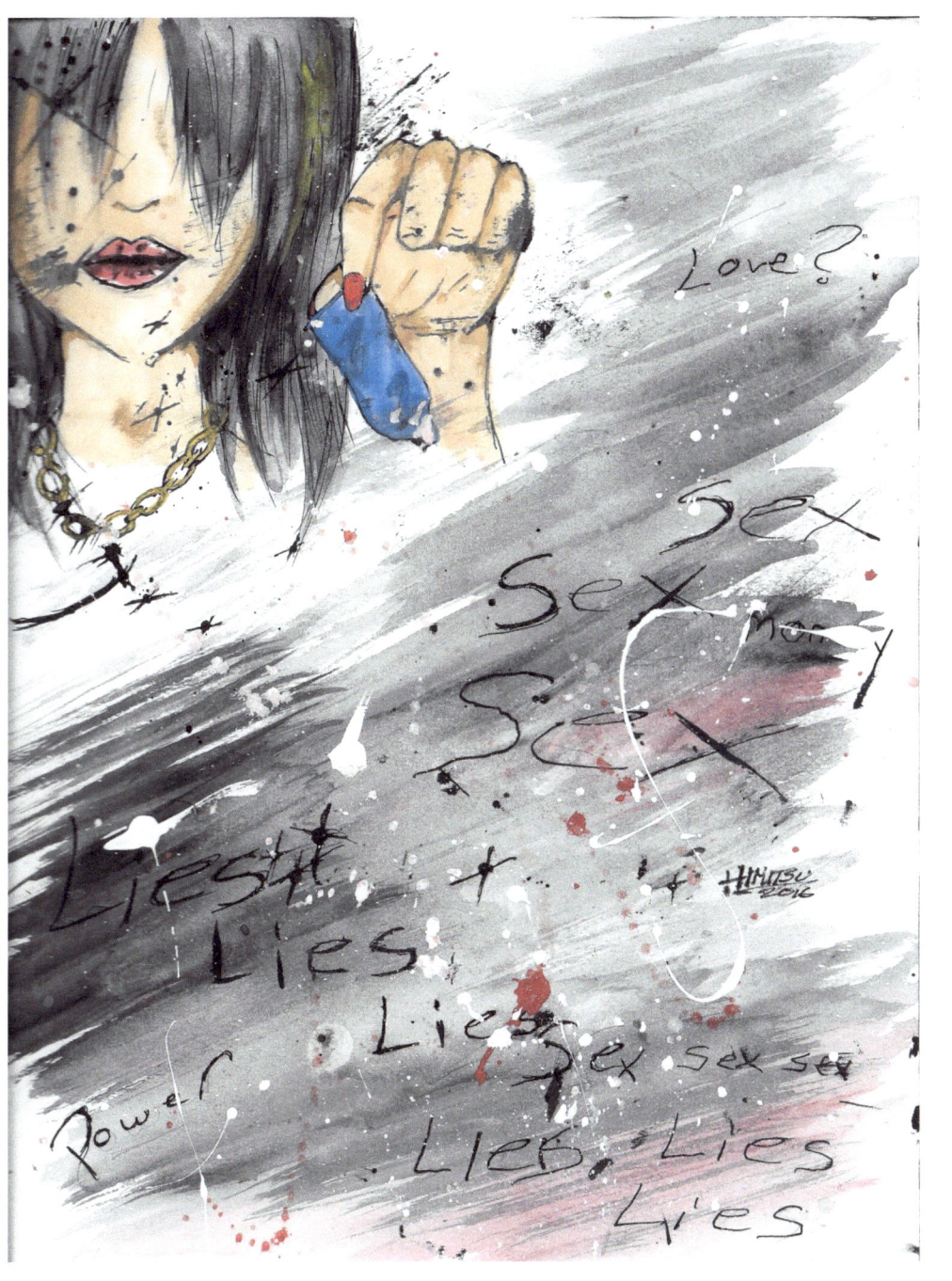

Sex & Lies (2016)
Acrylic, Ink, and Watercolor

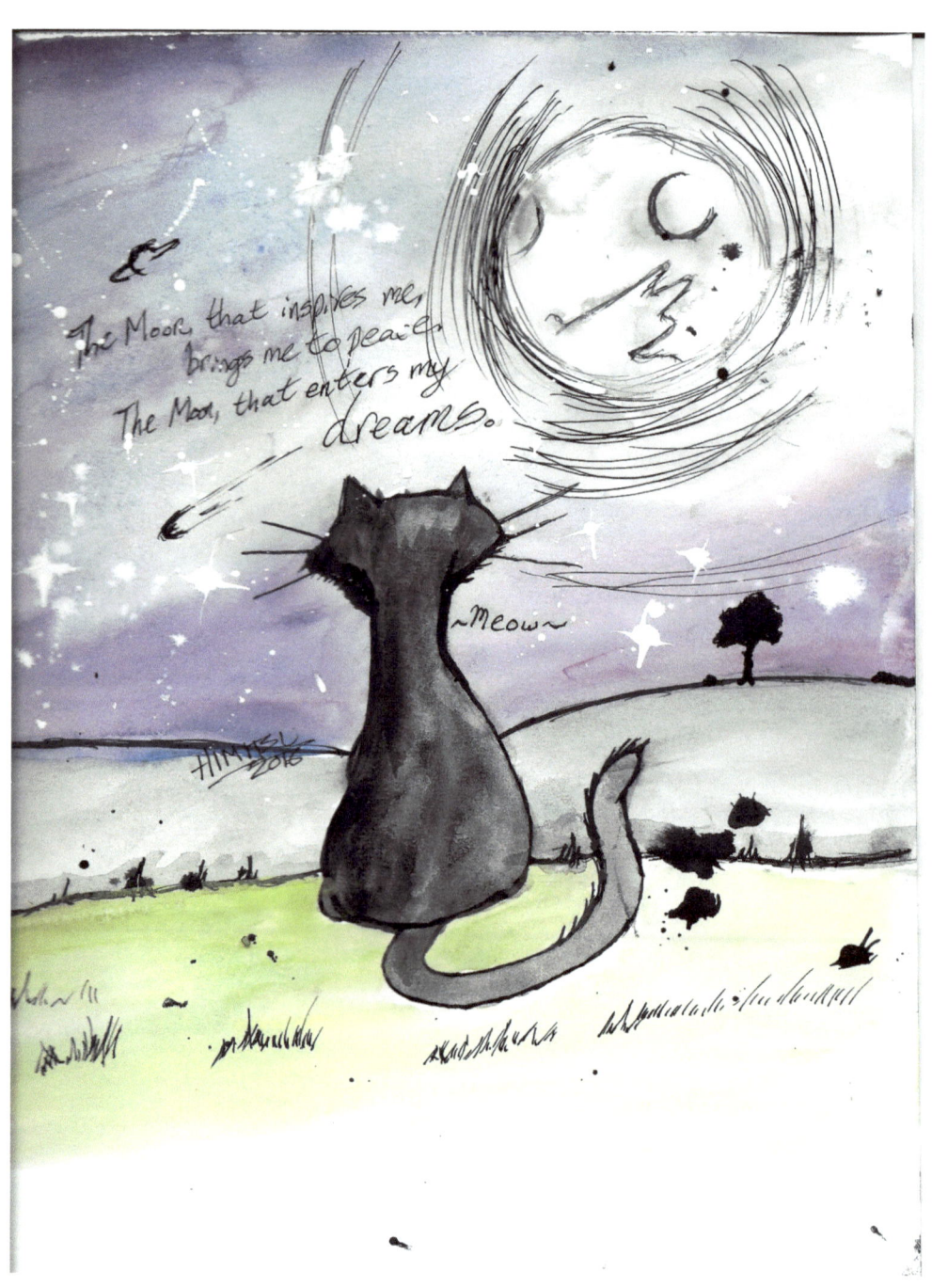

Selene (2016)
Ink and Watercolor

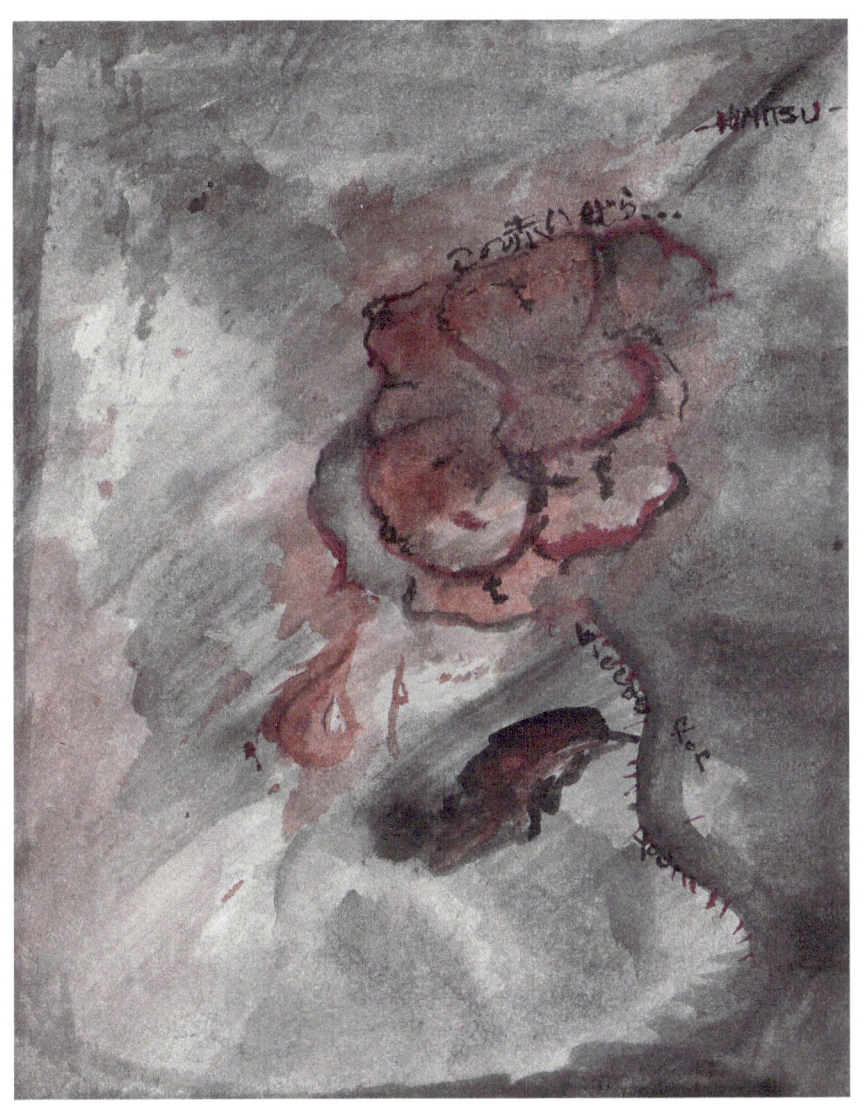

This red rose… (2015)
Ink and watercolor.

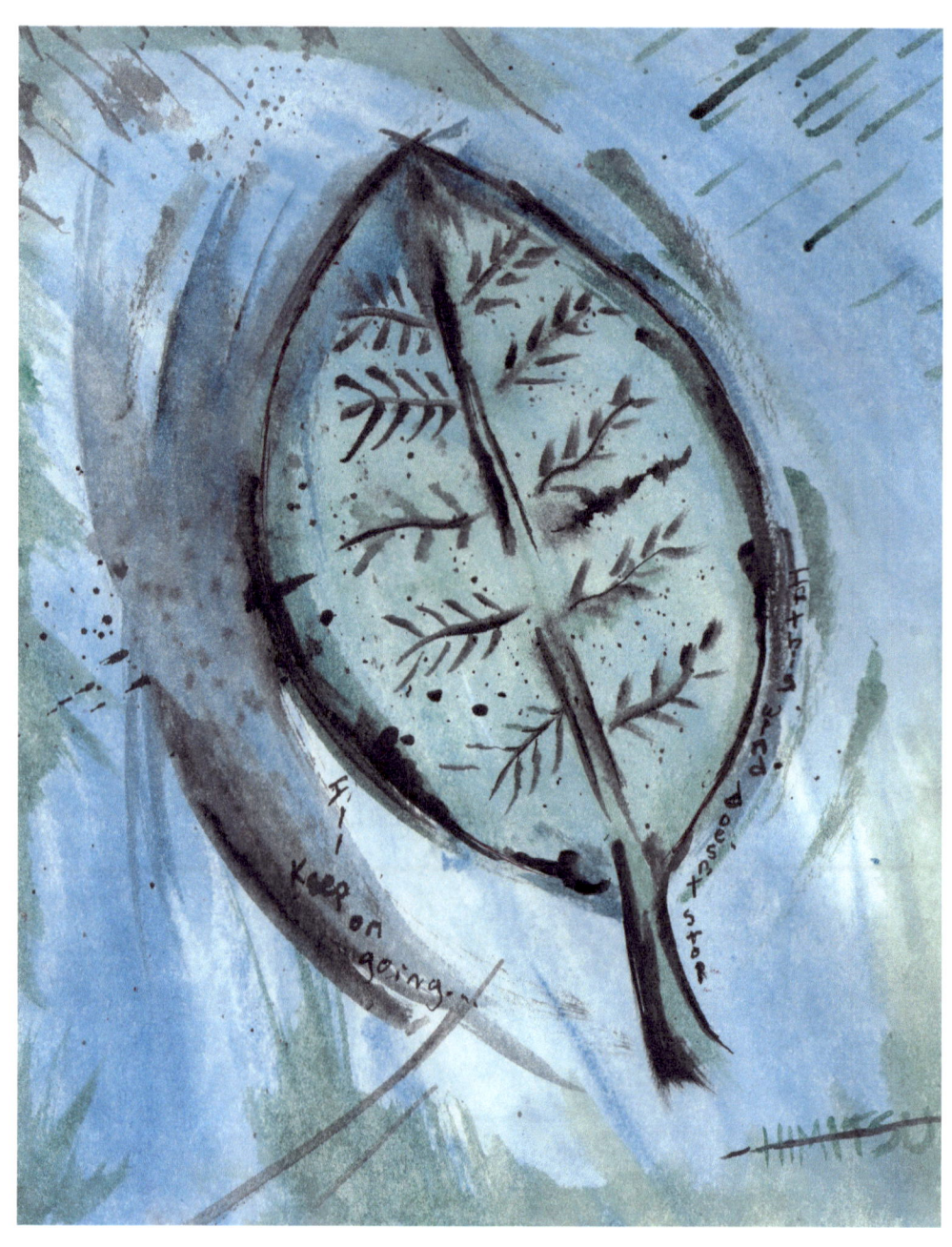

Happa (2015)
Ink and watercolor.

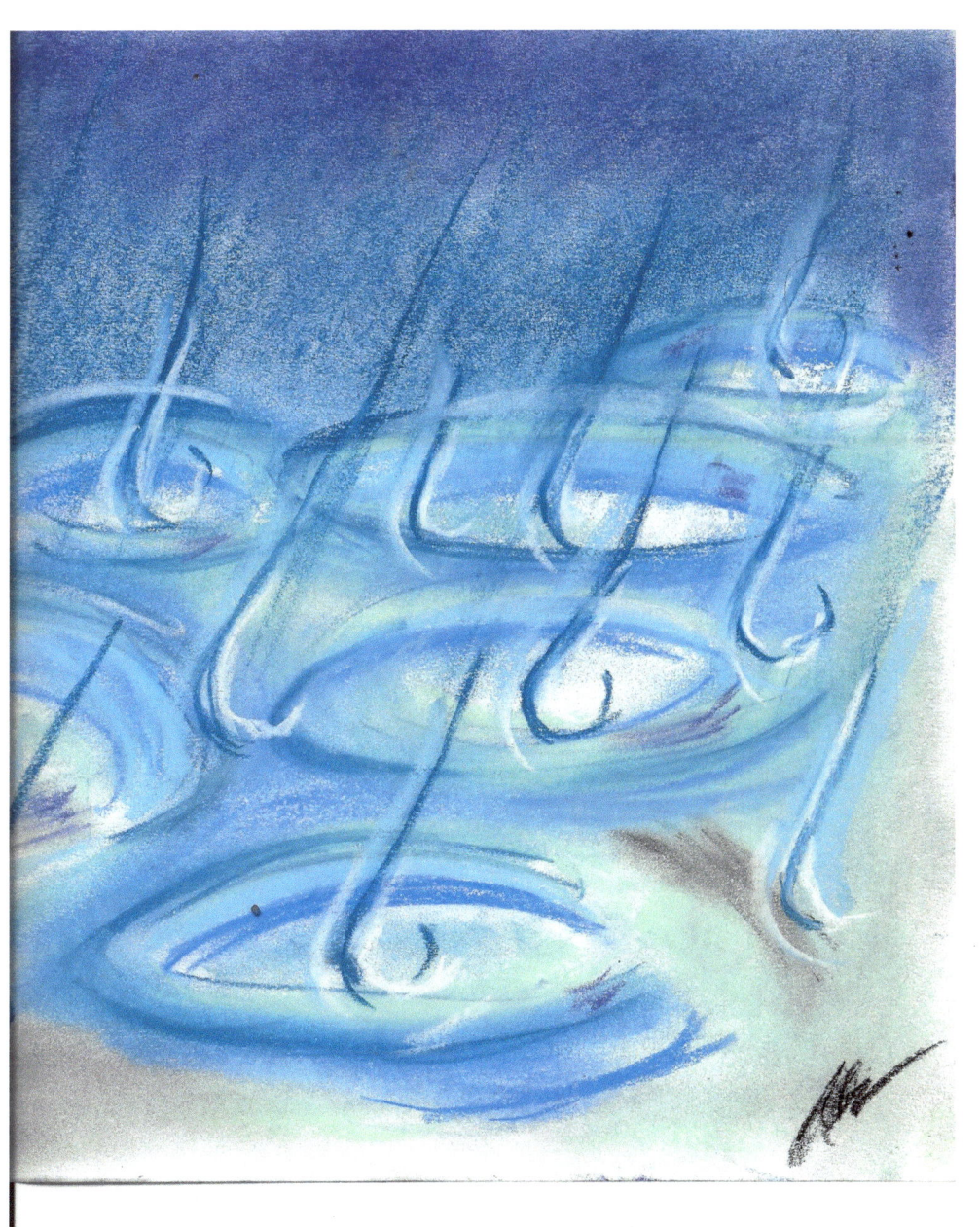

The Rain (2012)
Oil Pastel

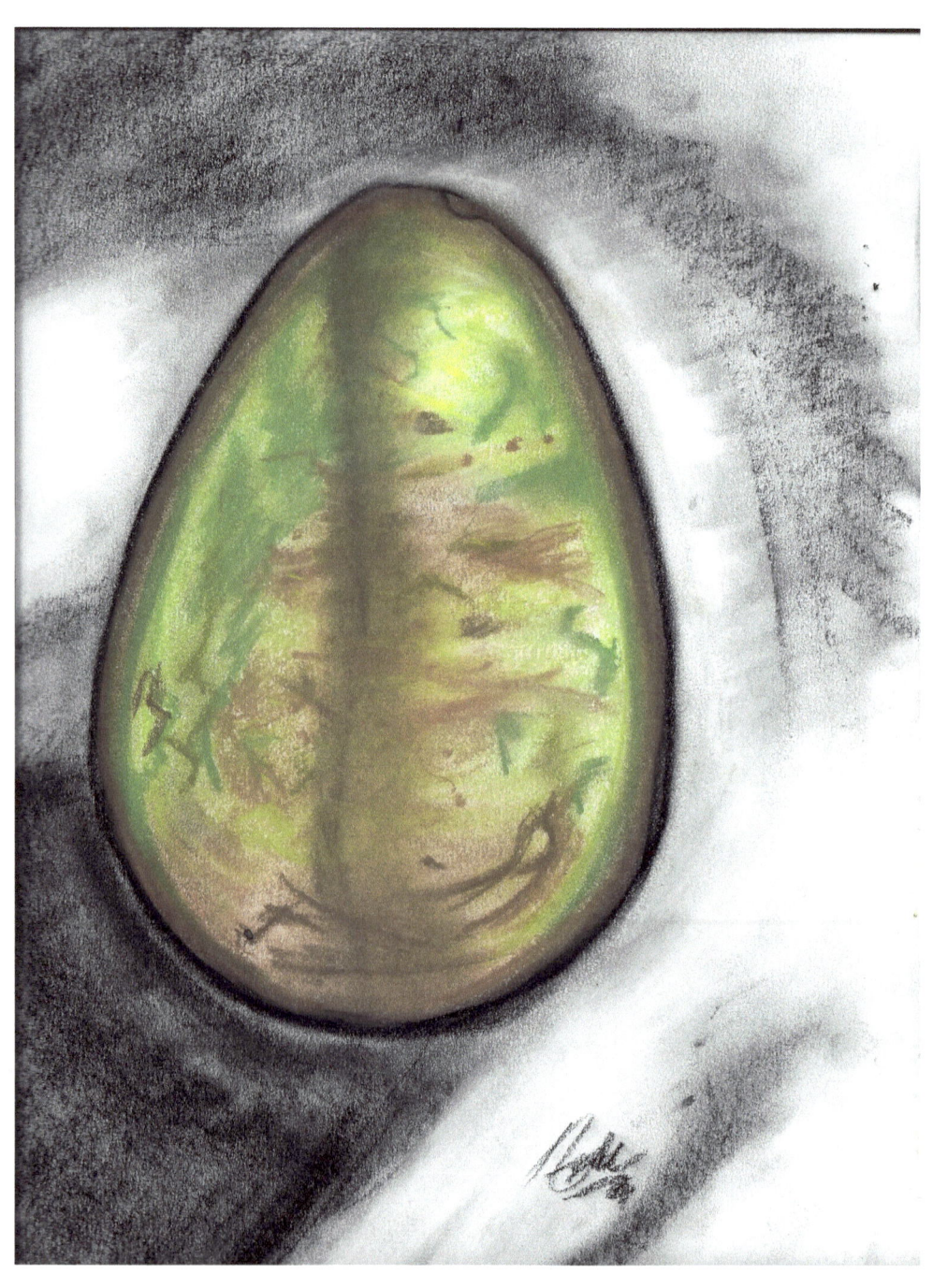

Avocado
2012
Oil Pastel

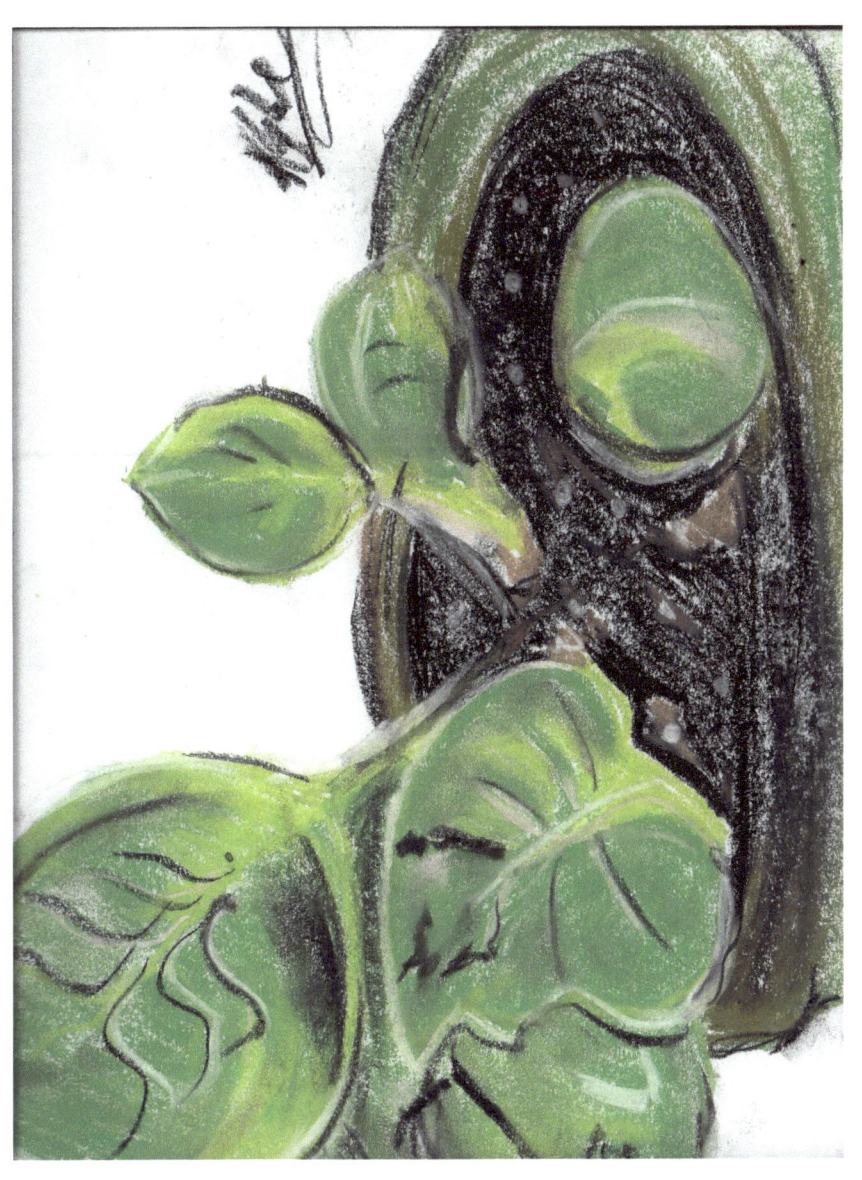

House Plant (2012)
Oil Pastel

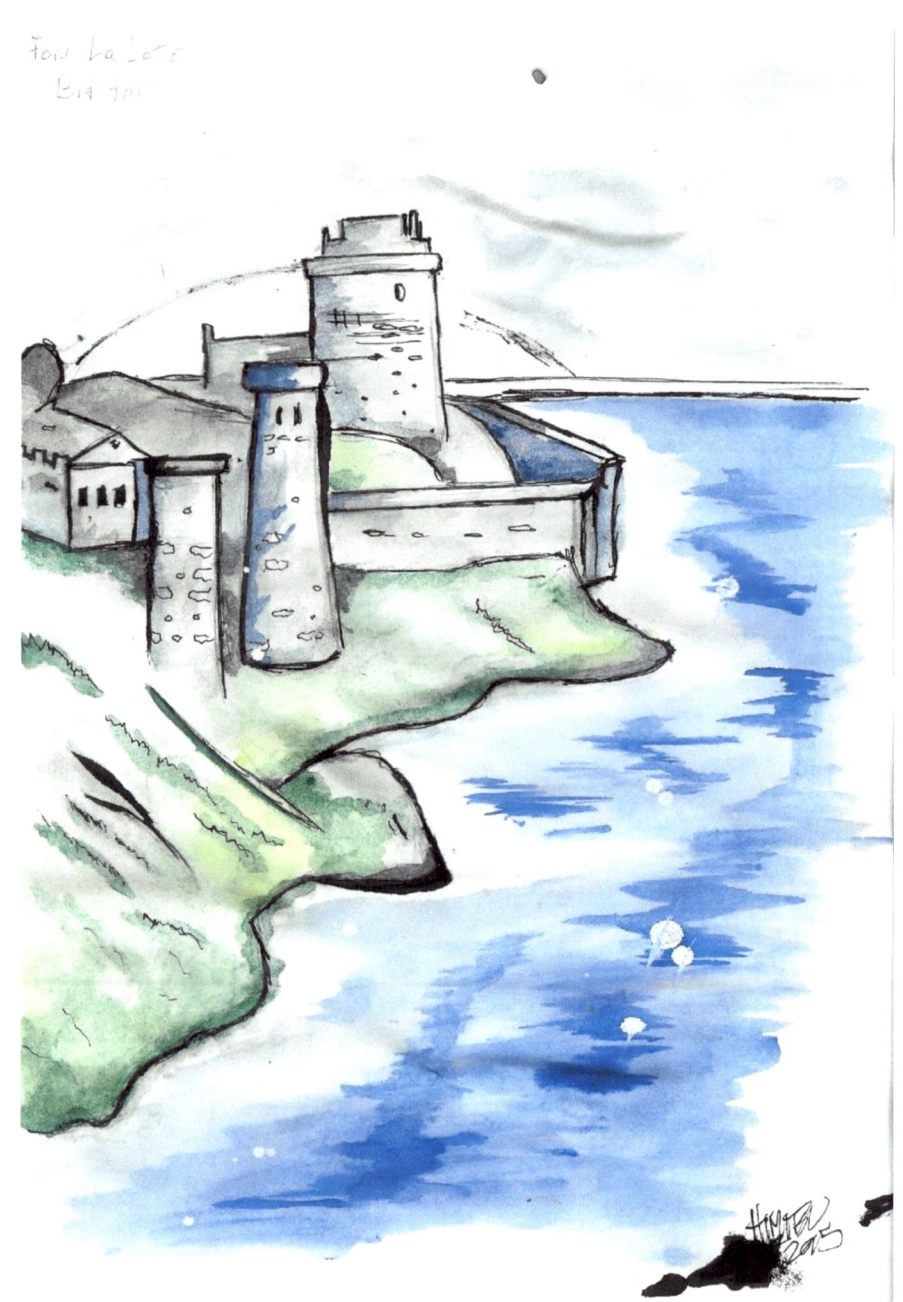

Fort La Lotte (2015)
Ink & Watercolor

www.ingramcontent.com/pod-product-compliance
Lightning Source LLC
Chambersburg PA
CBHW041117180526
45172CB00001B/295